ANIT.ME

FOR BEGINNERS

Introduction

Hi! Are you here because you want to learn the basics of drawing or because you want to learn how to redraw your favorite Manga and Anime characters? Or do you want to create new characters invented by you?

Whatever your need and why you came here, let me explain what you will find in this book.

In this book, you will find:
- all the basics on how to create anime characters, starting with basic anatomy and gradually deepening with facial and body structure;
- my technique and simplify how to draw the human body and folds of clothes;
- everything you need to start drawing your first complete character right away!

Most likely, this book will not make you a professional mangaka, as it is a book dedicated to those who are approaching Anime drawing for the first time and want to improve their basic techniques; however, it will give you the necessary pointers to create manga and anime characters created solely by your own hands!

Lesson 1
Basic Anatomy

基礎解剖学

1.1
Body Size

Male

When drawing your subjects, you must first know whether you are planning to draw a male, female, or child.
You can use the length of the character's head as a ratio of 1.
(From the top of the head to the chin.)

The upper body of the male character should be twice the length of the head. The bottom of the body should be the same as the head length.

Female

The female body almost works the same as the male body. The upper body should be twice the length of the head, but the shoulder should be less wider than the male character's.

The bottom of the body should be the same as the head, except that you make it a lot wider than the male character.

Child

The child's body works differently from the male and the female.
The upper and the bottom body should be the same length as the head. In addition, the child's shoulder should be drawn less wide than the female character.

1.2
Figure

Male

When drawing a male figure, there are a few things that you should watch out for. The male figure's shoulder should always be wide, and his arms should be nice and straight. The legs are drawn firmly, and they should be drawn apart.

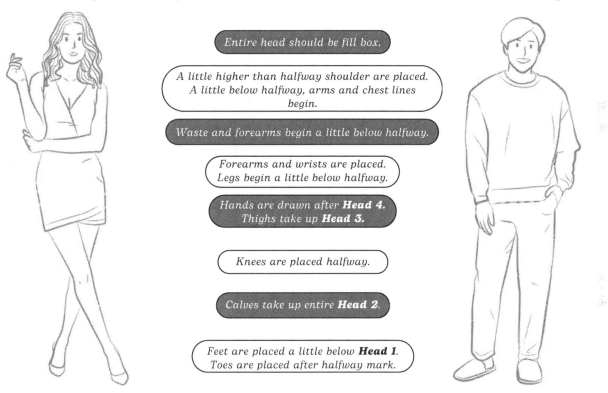

Entire head should be fill box.

A little higher than halfway shoulder are placed. A little below halfway, arms and chest lines begin.

Waste and forearms begin a little below halfway.

Forearms and wrists are placed. Legs begin a little below halfway.

Hands are drawn after **Head 4.** Thighs take up **Head 3.**

Knees are placed halfway.

Calves take up entire **Head 2.**

Feet are placed a little below **Head 1.** Toes are placed after halfway mark.

Female

When drawing a female figure, make sure it looks more lively by drawing it more freely and not too firmly. The shoulder should be a bit smaller than the male character, and the arm should be drawn outward, as shown in the example.

The waist is drawn inward, and the hip is drawn outward; this is what distinguishes between a male and a female character. Another thing you might consider when drawing a female character is her knee tends to move toward each other, as shown in the example. You will see this form a lot when they are drawn on the beach wearing a swimsuit.

1.3
Side View

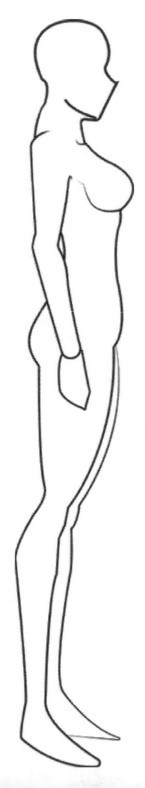

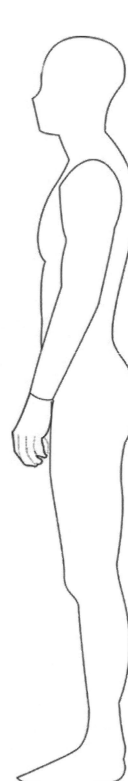

Male

This is your typical side view for a male character. Notice how the body is drawn a mostly straight line down. There are only a few curves for a male character, mostly on the back.

Female

The female side view is a bit more complicated than the male character. The body should be drawn with more "curves."
The main three spots that must be watched when drawing a side view are her breast, waist, and hip. Also, notice how the overall female body is smaller than the male character.

1.4
Anatomy

Here is your typical human body's anatomy (1). An Anime character (2) works the same as a real person. This works for both male and female characters; it may be different from one artist to another artist, but not very much. Please, be careful if you are still a beginner, don't make it out of proportion as a bad habit because it will be very hard to fix your style later.

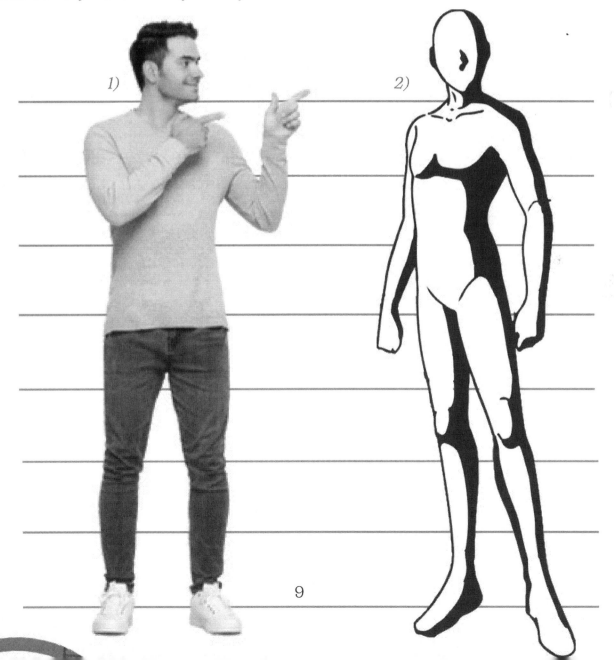

9

1.5
Male Chest

When drawing a man's chest, you must decide which type of man you want. There are three types: a skinny person, an average person, and a muscular person. By making the shoulder and the chest bigger with a few more details on the muscle, you can make a skinny person into a muscular person.

Skinny

When drawing a skinny male character, you should always ensure that the shoulder is not drawn too large. The chest is drawn curve down to the stomach. Add some lines near the neck and on the top of the chest to show his bones. Most importantly, don't forget to add the bone to the rib cage by drawing curve lines, as shown in the example.

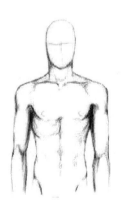

Normal

To draw a normal male character, you must make the shoulder larger. The chest curve down only a bit to the stomach. Notice that an average male character has no bone or muscle showing. This can be achieved by drawing only a few curve lines on the body. Making the chest looks very plain and less work for the artists since we don't have to draw in the rib cage.

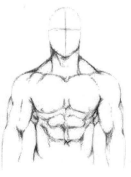

Muscular

To draw a muscular character, you must draw more details, especially the neck, shoulder, and stomach areas. The neck is drawn wider with defined details to show that he has veins on his neck. The shoulder and the upper part of the chest are extra large to show that he has muscle. Furthermore, remember to add detail for his stomach to complete the work, as shown in the example.

1.6
Female Chest

Drawing a female chest is different from drawing a male chest because you have to worry about the breast and the hip. The breast and the hip will define the aspect of a female character. Therefore, by changing the breast and the hip size, you can draw a supermodel to a muscular female.

In a female character, the shoulders are drawn close together. Her chest gradually curved inward to the waist and outward toward the hip. The hip width and the breast width should be about the same size. Furthermore, the two breasts should be drawn at about a 45-degree angle. The arms tend to be closer to the body for a female character.

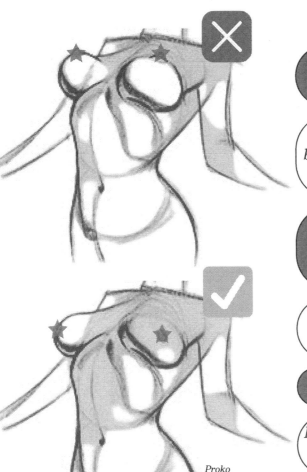

Proko

Tips about Boobs

Boobs are not round, they're actually teardrop shaped.

Natural boobs are thinner on top, fuller at the bottom. This is because of that pesky thing called gravity.

When laying down or in similar positions natural boobs get shy and run away to a girl's armpits.

Natural boobs like to hang when aimed at the ground.

Boobs are soft.

Boobs come in all shapes and sizes! Don't be afrai to experiment with a range.

11

1.7
Neck &
Shoulder

The neck and the shoulder both work the same way for a male and female character, except that the female neck and shoulders are a bit smaller than the male character.

The shoulder is drawn upward toward the neck, like walking up a hill. The common mistake for a beginner is drawing the shoulder too flat toward the neck. As for a muscular person, the shoulder should be drawn higher than a normal shoulder, as shown in the example.

A female's neck is slim and curvier than a male's.

A female's shoulders are soft and curved

The collar bone and neck line is less defined, keeping the female appearence simple and graceful.

A male's neck is well defined and thicker than a female's.

A male's shoulders are very broad and muscular.

The collar bone and neck line is very potent on a male. Keep wary on this area.

1.8
Arm Rotation

Arm rotation is probably the hardest thing to learn when you are a beginner, but with little practice, you can be a pro. Some artists, especially beginners, need to realize the importance of making the proper arm rotation. It makes the characters look more realistic. You must know certain things when making the arm move: the shoulder moves with the arm. When you draw the arm up, down, outward, or inward, the shoulder moves up, down, outward, and inward respectively.

Please study the examples below carefully.

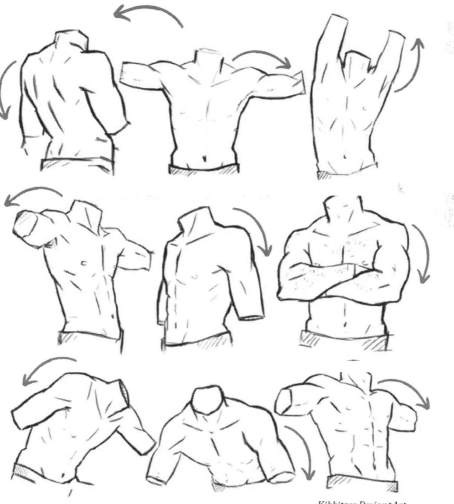

Kibbitzer.DeviantArt

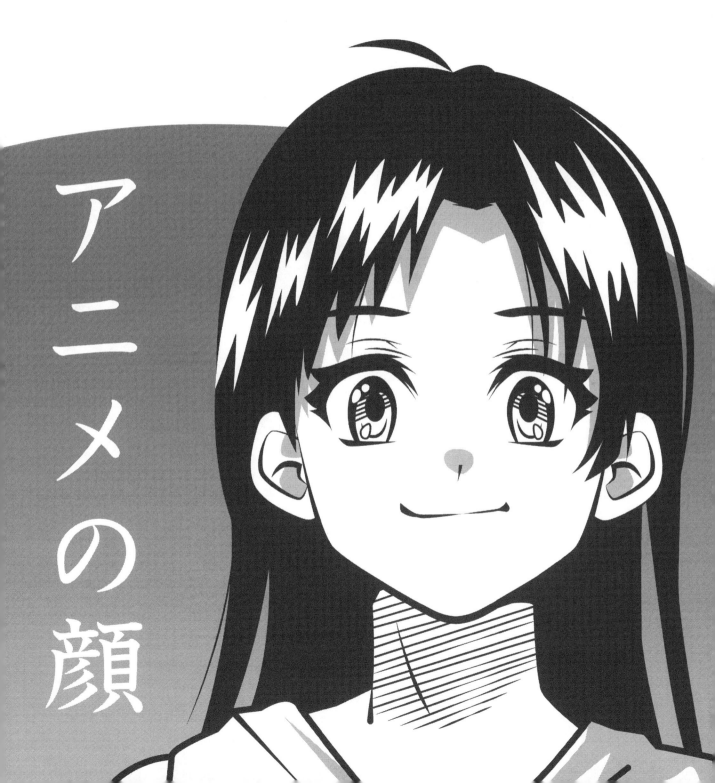

Anime Faces

アニメの顔

2.1
Cross

As you are learning how to draw anime characters, you should first realize that every character you draw should start with the head. Before you start drawing, you will need to center the head by drawing a little cross, as shown below. However, you will probably notice that most of the anime characters you see are usually facing left or right, and you hardly see them facing toward you. This is because making them face right or left makes the characters look more "3D".

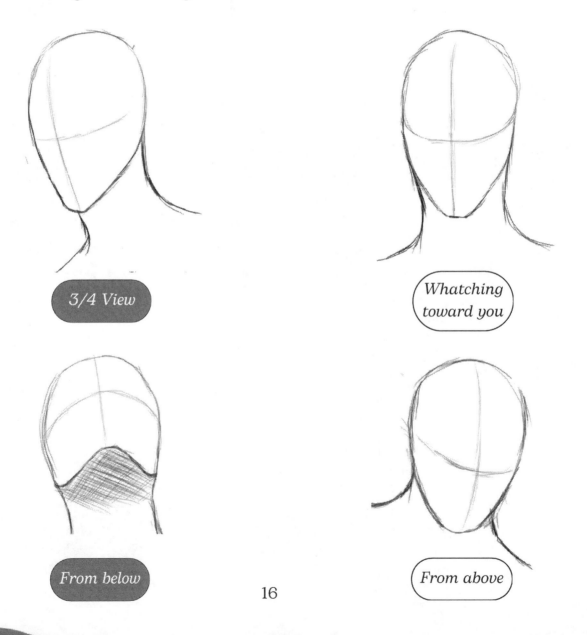

3/4 View

Whatching toward you

From below

From above

2.2
Eyes

Drawing the eyes is the most important thing for an anime character. Therefore, we have decided to break it into two parts. The first part will show you the type of eyes available for drawing, and the second part will teach you how to draw the eyes in detail.

There are thousands of ways to draw an eye, but for now, you only need to know the three basic types of eyes: *oval*, *triangle*, and *rectangle*. The three styles work for both male and female characters.

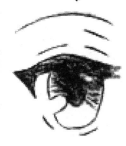

The oval eyes are your typical "Happy Anime Character" or "Cute type," as some of you may call them. It's the most common eye you will see when watching your favorite anime show.

The triangle eyes are your typical "Mean Anime Character" or "Your Bad Guy Character." You don't see many triangle eyes when watching anime, but occasionally you see some bad guys with triangle eyes.

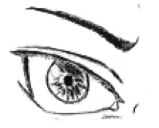 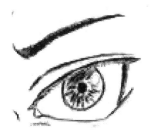

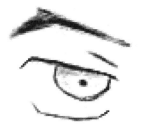

The square/rectangle is your "Average Anime Character" or "Innocent Girl/Boy" looking type. You will notice that most of the anime you see on TV will contain rectangle eyes which will make them look more innocent.

When drawing the eyes, you should take your time and draw them carefully. The eyes will make your character what they are; therefore, one should spend a lot of time practicing drawing the eyes.

Most importantly, when drawing the eyes, try to remember the top and bottom eyelashes, the sparkling in the apple of the eyes, and color the apple carefully.

2.3
Female Eyes

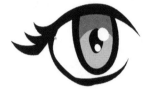 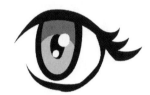

Oval Happy Character / Cute Type

 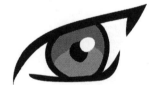

Triangle Mean Character / Bad Characte

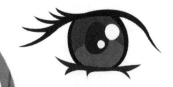 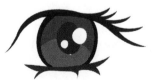

Square / Rectangle Average Character /
Innocent Type

2.4

How to draw Female Eyes

As mentioned earlier, the eyes are the most important thing in an anime character; it makes the character what they are. As shown below, this section will teach one how to draw female eyes. If you can draw this, you will have no problem drawing the triangle, oval, or rectangle eye type because they work the same.

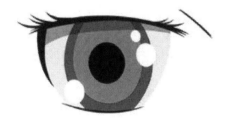 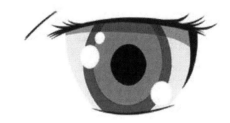

STEP 1

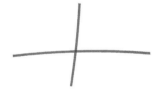

The first thing you should do for a beginner is to draw a cross. The cross you see below are facing a bit just toward the left. It is not fully facing straight toward you, but you can draw it that way if it makes you feel better.

STEP 2

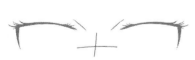

The place where the interection cross, is where you should start drawing your nose. You don't have to draw the nose now, but if it makes you see better then you should. The top of the nose is where the intersection of the cross meet. Now just draw a curve below the cross to represent the nos as shown. If you decide to draw the nose now then you might as well draw the mouth. Let's just draw a simple mouth for now.

You do this by drawing a little curve below the nose and it's done.

STEP 3 : How do you know where to draw eyes from the cross?

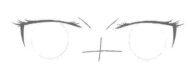

Well, in this case since the face (cross) is facing left, you must draw your right eyes further then your left eyes from the cross intersection.

The distance between the two eyes should be about 1.2 apart as shown. If the face (cross) is facing right instead of left, you must draw your lefft eyes further than right eyes from the cross intersection.

The next step is to draw the top and bottom eyelashes. All you have to do is darken the above and bottom of the eyes and draw some lines sticking out for your eyelashes.

After that draw a line over the eyelashes to complete the outline of the eyes.

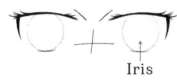

Iris

You can draw sparkling by making a oval shape within the eyes. Don't make it too large, about 1/4 of the iris size.

The iris will contain sparkling and some little white oval shapes.

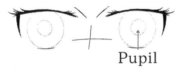

Pupil

The sparkling can be drawn from the top left corner of the iris as shown. You may draw the sparkling from the top right corner as you wish. The pupil should be drawn at the centre of the eyes.

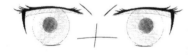

Next step is to draw more details around the iris. Also, you can draw some more oval shapes around the pupil to make more sparkling.

Normally, 2-3 glares are good enough.

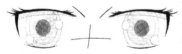

Now all you have to do is fill in the top part of eyes and the sorrounding area and you are done with eyes.

Try not to draw too many sparkling because it will make it looks unreal.

Drawing the eyes is prbably the hardest thing to do for any beginner and it will take some times to get use to it. Therefore, be patient and hopefully you will get use it very soon. It takes about one minute to draw the eyes for a pro, but for beginners this may take about 30 minutes.

2.5
Male Eyes

Drawing a male eye is the same as the female eye. However, a male eye is generally a bit smaller and contains less sparkling than a female eye.
Occasionally, the male eye can be drawn a bit larger when drawing a male child.

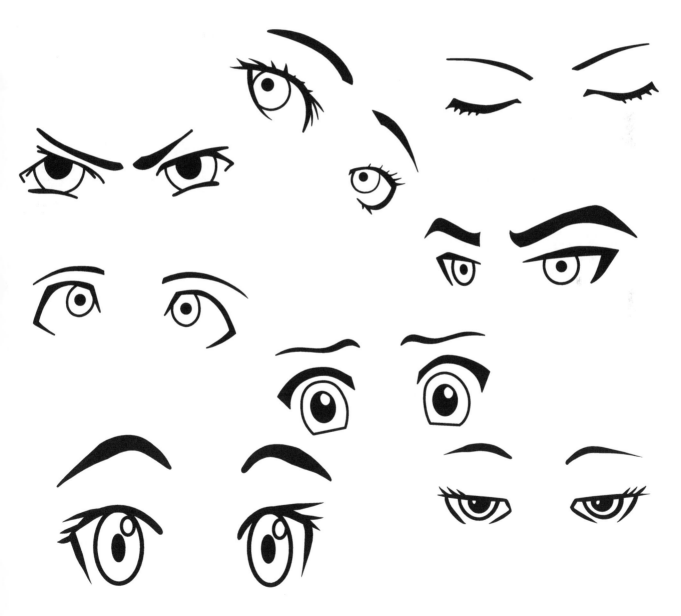

2.6
How to draw Male Eyes

STEP 1

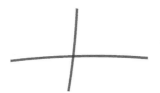

Start by drawing a cross as in female eyes.

STEP 2

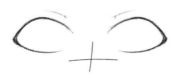

In female eyes, the eyes are drawn almost in a full circle, but for male eyes, the eyes are drawn in half a circle. Most male eyes are smaller, narrow, and thicker line than female eyes. After drawing the half circle, define the eyes by adding the eyelids on top.

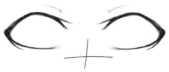

The iris is almost a perfect circle but is partially covered up by the eyelids. Do not draw the iris so small that you can see the entire eyeballs.

STEP 3

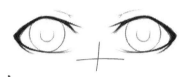

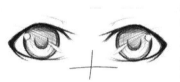

The male character's eyes have light glares, too, but they often are not as large or obvious as in the female eyes. Therefore, one should keep this in mind when drawing the male eyes.

The next logical step is to draw the pupil. Just draw a smaller circle within the iris, as shown in the example.

As for the glare, draw one oval light glare on the left side of the eye and the other one on the right side.

Notice how the glares are not too obvious as in the female glares.

You can draw the eyelids thicker than the female eyelids. In most cases, they are drawn thicker.

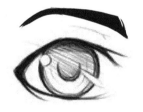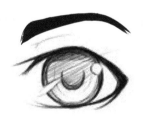

Male characters tend to have darker, thicker eyebrows, so ensure they are not drawn too thin.

Usually, the male eyes do not contain eyelashes, but if you want to draw them in, there is nothing wrong with it. However, most manga artists don't usually draw the eyelashes for the male eyes. You seek your style and unleash your creativity, in which case there will be nothing wrong if you bring variation to the art of manga.

2.7
Eyebrows

Many artists prefer to draw eyebrows immediately after drawing the characters' eyes. Drawing eyebrows is an easy task, but it can bring huge variations because, with eyebrows, we artists have to communicate the emotions of our characters. We can make them look sad, happy, angry, and much more by simply changing the slant and expressiveness of the eyebrow. Therefore, you should know from the beginning what expressiveness you want to give your character before drawing eyebrows, and most importantly, take your time. As a beginner, you should keep the eyebrow style as simple as possible. Drawing a regular expression is easy. All you will have to do is draw a curve above the eyelashes.

The only difference between male and female eyebrows is that it is generally used to make the male eyebrow much thicker and thicker.

In this part, more than analyzing the drawing technique, we will focus on emotions and the shape they take for different emotions since the eyebrow is super easy to draw.

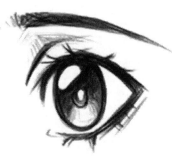

Regular

To illustrate a neutral facial expression, one needs to draw a slightly curved line starting just before the beginning of the eye and tapering and extending just after the end (to help, imagine two vertical lines starting at the beginning and end of the eye).

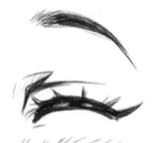

Joy

An excellent way to enhance joy and happiness is to draw a curved eyebrow and simultaneously illustrate the closed eye with an upward-facing semi-circle.

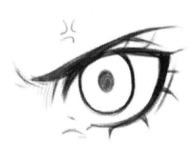

Anger

Remember that when illustrating angry characters, the features become much more angular: the eyebrows, first of all, start from a very low position and extend upward as a sort of "V"; the eyes become much more pointed and take on a *triangle shape* (which we discussed earlier).

Surprise

To represent surprise, we can open the eye almost without eyelids. Also, the eyebrow's arch is very curved, and the iris is inside the eye so that it can be seen ultimately.

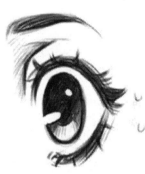

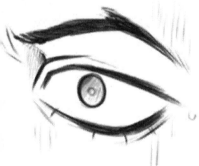

Scare

The expressiveness related to fright can represent it very similarly to "*surprise*," except for a few differences: the pupil and iris should be drawn much smaller than the eye, and in some cases, it may be much more useful to illustrate the iris and pupil in a single circle; the eyebrow is lower and less curved.

Sadness

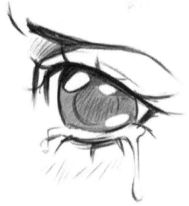

You can illustrate sadness differently, depending on how enunciated and intense you want it to be. Generally, to represent sadness, it is useful to draw the eyebrow starting from the top down, like an inverted "V"; the eyes turn out to be much more closed, and you notice the eyelids more. Also, add tears to make it more emotionally charged.

2.8
Mouth

Drawing a mouth is the easiest thing to do. There is only a little you need to learn about drawing the mouth, except that you should remember to draw them proportionally to your character's face. Also, the male mouth is usually larger than the female mouth.

Keep the mouth as simple as possible by drawing a long thin line for the mouth.

I suggest adding a shorter line to define the lower lip.

Like the eyebrows, the mouth represents another feature that can give more expressiveness to our characters.

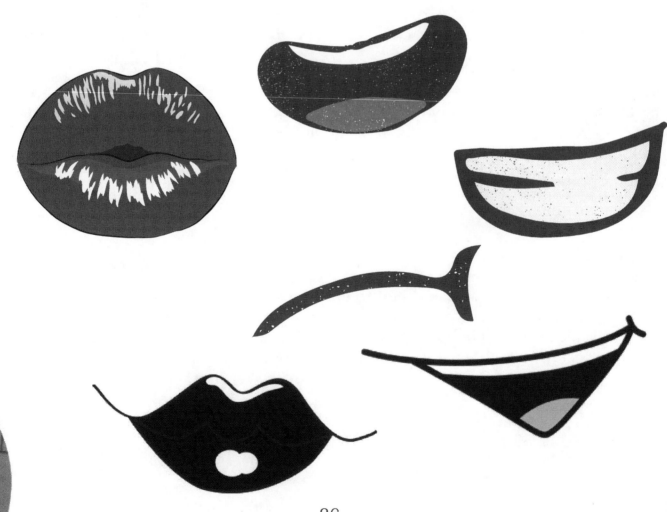

2.9
Nose

Drawing a nose is simple; this may vary from how you would like to style it. Remember that drawing a small nose in the mangas is preferred. In general, when you have a big mouth, you should also have a big nose, and vice versa. Sometimes artists like to draw the nose with a simple dot or a few small lines. It is easy to find a stylized nose with only two dots (representing nostrils) in mangas and anime characters.

Let's go back to our drawn cross; remember that under this intersecting cross, the nose will have to be drawn (in the final chapters of this lesson, it will all become more explicit regarding the face's proportions). The top of the nose will start from the intersecting cross and curve slightly, depending on the perspective. Remember to make the nose length neither too long nor too short, but it should be harmonious with the rest of the proportions. As a beginner, you should only draw noses that are fancy. Try to keep to as simple a style as possible.

Not Stylized Nose

Stylized Noses

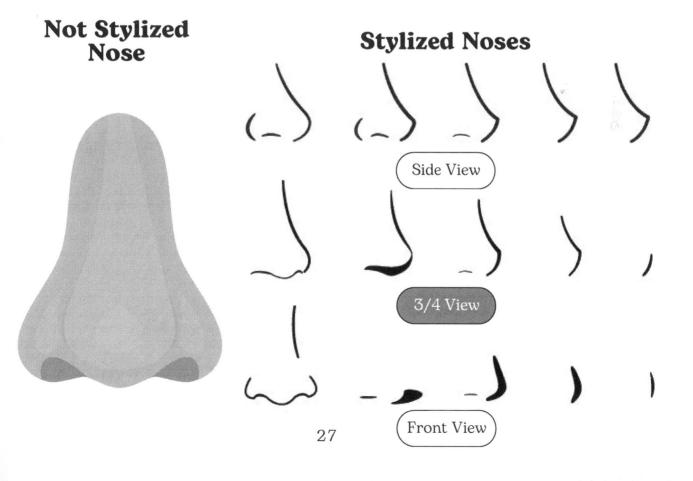

Side View

3/4 View

Front View

TRY IT YOURSELF!

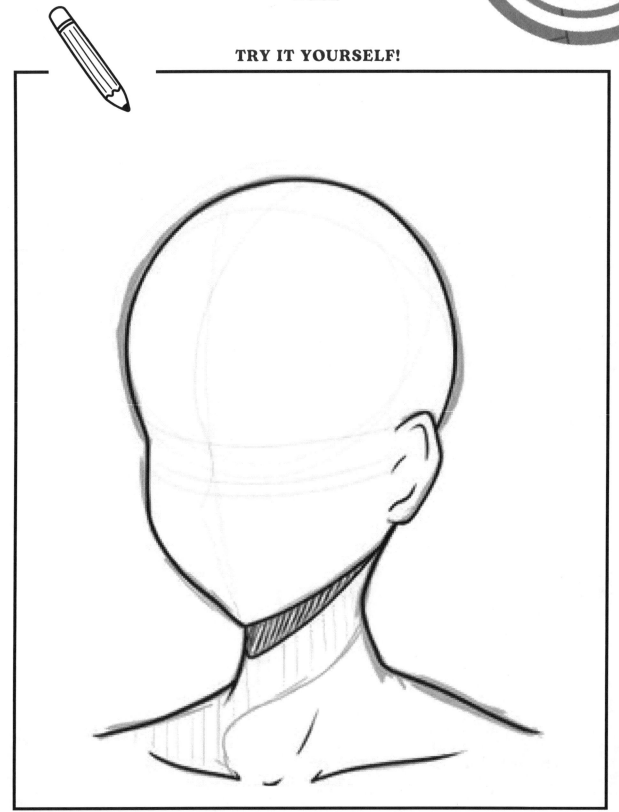

2.10
Ears

Learning to draw an ear (or both ears) at first glance may seem difficult, but it is actually much easier than it looks. Many of the ears of the characters you see on TV are very simple. Artists like to keep ears very simple.

The tip of the ears should be a little lower than the top the eyes (help yourself by imagining a horizontal imaginary line). The ear lobe should be located a little below the lower part of the eyelashes, or you can imagine a horizontal line from the tip of the nose and exactly where it intersects begin drawing the ear from below. Never draw the ears as if they are actually sticking out to avoid the "floppy ears" effect, although some manga like to style them this way.

When the outline are done for the ears, the next step is to draw some curvy lines within the ears. The ears style work the same for both male and female character. In addition, one may add some ear rings to the ear lobes when drawing a female character.

Not Stylized Ear

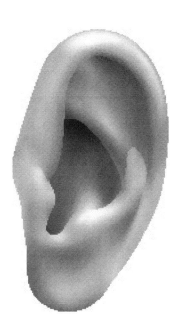

Stylized Ears

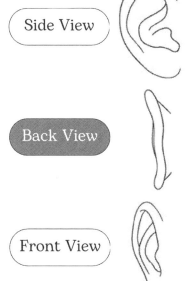
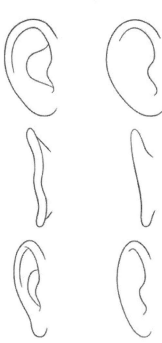

Side View

Back View

Front View

2.11
Hair: Female

Drawing hair to female characters is undoubtedly the most difficult task for an artist. It requires years of practice drawing and drawing again and again. For a beginner first you have to draw a hair line across the face. The hair line should be approximately 1.5 higher than the height of the eyes. Before, drawing the actually hair, please note that anime hair consists of two parts:
the bangs in the front of the character face that hang down over the eyes, and the larger back portion of the hair that hangs down at the back of the head.
From the hair line draw curvy lines down; this will be the front bangs.
The back portion of the hair curve toward and downward the shoulder.
When everything is in place, draw the lines thicker to make it more realistic.

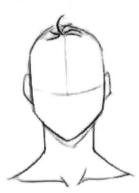

STEP 1
Let's start by drawing the "root" of our hair, that is, where we want it to start and extend in the desired way. In the example on the left I have taken as a reference a hairstyle that extends from the center, but you can change according to the look you want to give your character.
Remember that the lines should be curvy and draw you with a light hand.

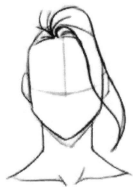

STEP 2
Here our "topknot" begins to extend across the face. As you can see the hair is not straight and stiff, but soft and natural. Also, remember not to draw the hair excessively attached to the head since the hair gives volume it is advisable to imagine a circle around the character's head so that you do not draw the hair too close to the skull.

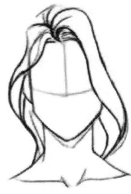

STEP 3

The hairstyle begins to take shape and the bangs are complete. In the next step we will deal with drawing the back portion of the hair and adding the various details.

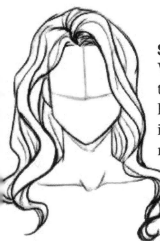

STEP 4

We have finished. Notice the details in the hair and especially the volume effect they give to the head that no longer looks like an oval only. Remember that hair is subject to gravity, so it will always tend downward; also, hair is dynamic so you will need to always draw yourself with a loose hand.

Ideas for hairstyles

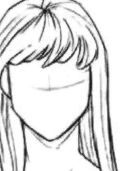

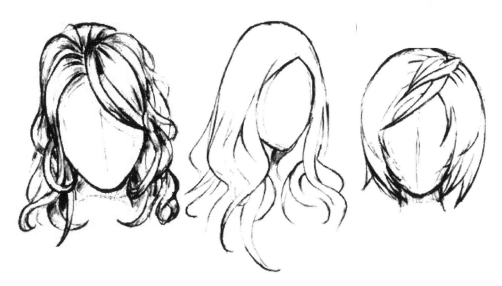

TRY IT YOURSELF!

2.12
Hair: Male

Drawing a male hairs is easier than drawing a female hair because it contains less detail. Same as before the hair line should be about 1.5 higher than the height of an eye.

Before, drawing the actually hair, please note that male hair consists of one part only: they are not separate as in the female hair. From the hair line draw curvy lines down; this will be the front bangs. The back portion of the hair curve toward and downward toward the shoulder. When everything is in place, draw the lines thicker to make it more realistic.

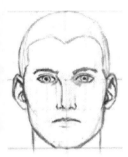

STEP 1
Start by drawing the hair line

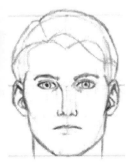

STEP 2
Immagine what type of hair style you want and to which direction the hair strands flow. Try drawing simple chunks of the hairstyle you want.

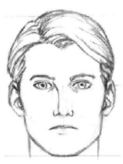

STEP 3
Add more detailed lines to the initial style you envisioned to make the hair more realistic. Use a dark marker on the outlines of the hair you have drawn and erase all unnecessary lines and curves from your outline.

Here are some **simple** types of hairstyles that you can use as references and try to design on the next page.

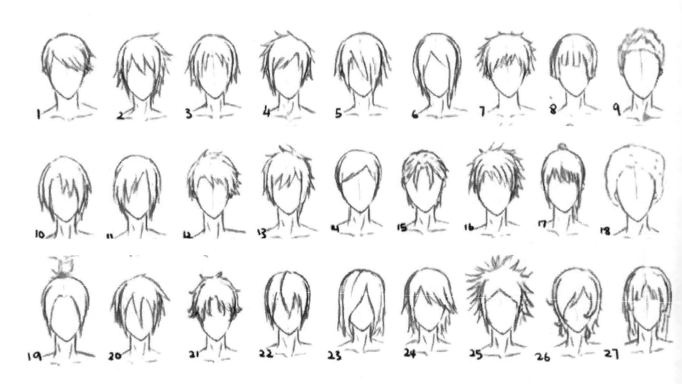

Here are some **hard** types of hairstyles that you can use as references and try to design on the next page.

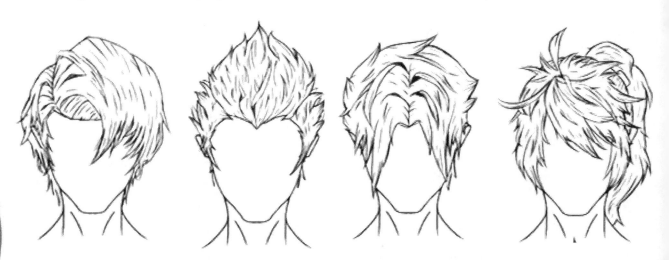

TRY IT YOURSELF!

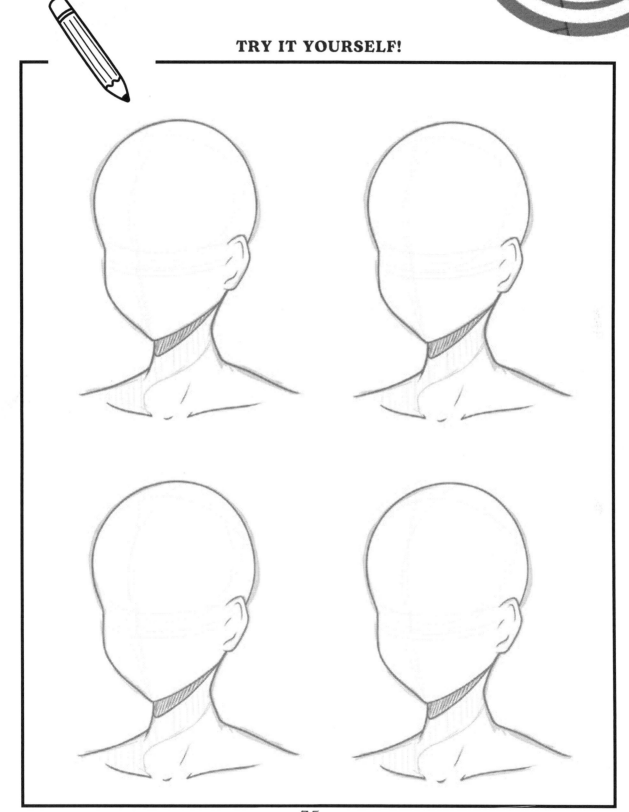

2.13
Female Head Drawing

If you are drawing the complete female face for the first time, it will not be an easy task. It requires a lot of experience and practice.

At the end of this lesson you will find female face templates (with guidelines) in which you can practice.

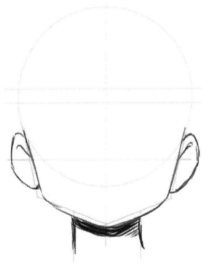

It starts with a circle and a cross..

Before anything else remember to draw the intersection cross facing you, therefore without perspective and essentially symmetrical. Around the intersecting cross draw a large circle that will be the shape of our head. You may find it easier to draw the circle first and then the cross in the middle. Once this is done stretch the circle toward a point at the base, as if to draw a triangle, this will be our chin and jawline.

Remember that in the female face the lines should be softer and more sinuous.

Add eyes and eyebrows..

Look carefully at the example on the left and you will notice that the eyes and eyebrows have been placed in the guidelines respectively. Of course, it must be remembered that every face has its own proportions, and you can feel free to experiment with the proportions according to the style and impression you want to give your character.

Also, do not forget that the female neck is much thinner and more delicate than the male neck.

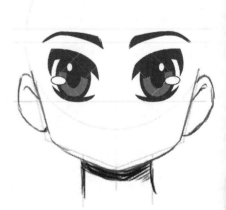

36

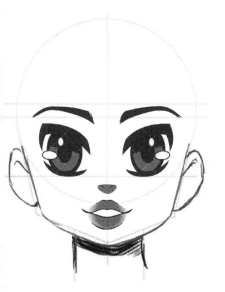

Add mouth and nose...

Once you have completed the eyes and eyebrows you can start drawing everything else. Start with the nose by illustrating it in a very minimalist way; in the example on the left it was illustrated using only two dots and a shadow representing the shadow cast downward by the light. Also, remember to give more volume to the female lips to better distinguish them from the male ones.

Don't forget the hair..

Once you have everything in place begin to draw the hair step by step in the technique we went over in the lesson on women's hair. Before you finish there is one last trick: erase the guidelines we used to make the drawing much neater and cleaner.

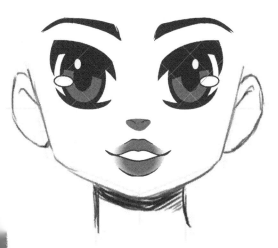

TRY IT YOURSELF!

38

2.14
Male Head Drawing

Drawing a male head is no more difficult than drawing a female head since the process is almost the same. However, some details need to be changed for the male face. First, the hair; generally, males wear it shorter. Male eyes are smaller but with thicker eyebrows. The male mouth tends to be wider and the neck wider than that of females.

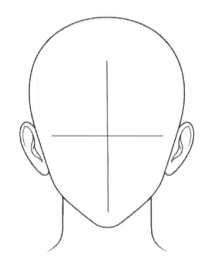

It starts with a circle and a cross..
As in the female face, drawing a male face requires a cross and an oval.

Add the eyes..
Draw the eye shape you like best and add eyebrows. Don't worry; this is nothing new, and you already did this when we drew the female face.

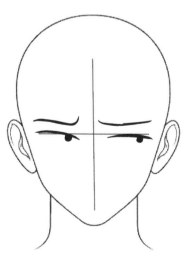

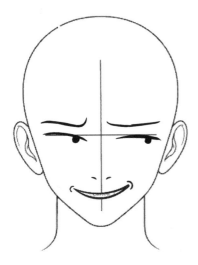

Add nose, mouth and hairs..

Once you have completed and stylized the eyes, you can start drawing the nose and mouth.

Draw the mouth slightly below the nose and try to keep as much of the real proportions as possible, but also try to style it to your liking. Next, proceed with the hairline, start sketching a hairstyle, and then add details.

TRY IT YOURSELF!

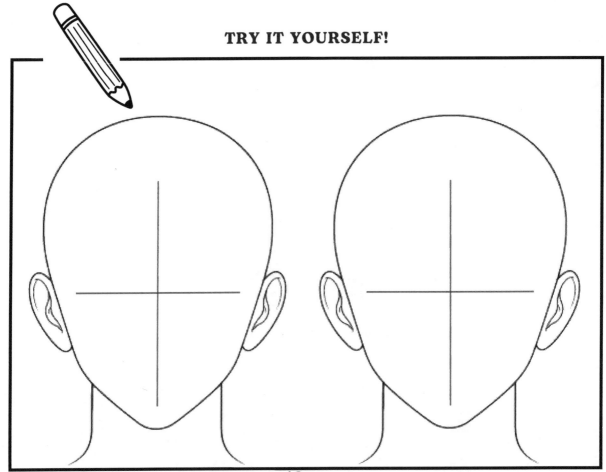

40

2.15

Common Mistakes

Over the years I have noticed common and frequent mistakes that are made by beginners. The first mistake I notice is that the top of the hair is too thin and close to the scalp, as I said a few chapters ago "hair gives volume to the head" and it is important to always keep that in mind. The second mistake I detect in in beginners is drawing lines that are too straight, making the faces of their characters look like they are too robotic and not very human. The third frequent mistake is that the ears are drawn too "flapping," that is, they are drawn as if they are pointing toward you, instead, in a frontal character, they should be drawn outward, thus giving them some perspective. The last mistake I would add is that the eyes are usually not drawn proportionate to the face.

Lesson 3
Bodies

中級図面

3.1
Muscles

Muscles perform a vital function in the human body: it is because of them that we can lift and/or move weights. Remember that every muscle has a function and changes shape based on movement.

Remember that sketching the muscles in your dummies is the last process. Look at the figure below, and on the following pages, we will look at the muscles below, as these are the ones we did not discuss previously.

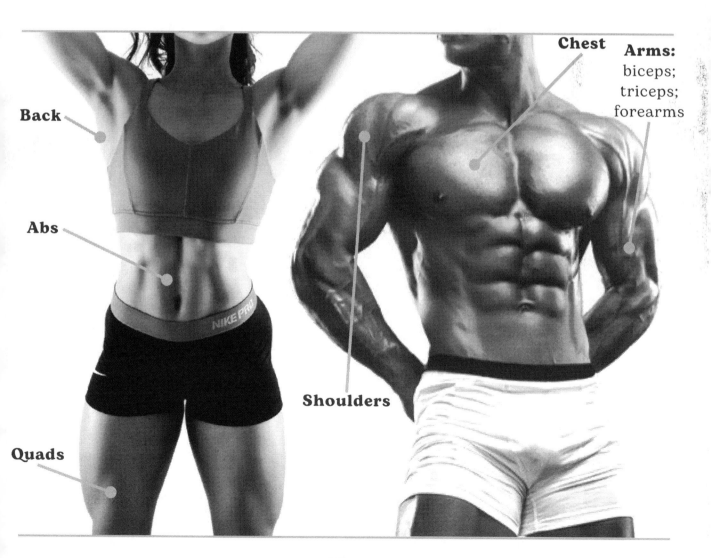

Back

Chest

Arms:
biceps;
triceps;
forearms

Abs

Shoulders

Quads

3.2
Male Torso

We can divide the muscles of the male torso into four groups. The chest (which we discussed in the first lesson), the abdomen, the oblique abdomen, and the back. These large muscles are, in turn, composed of other smaller muscles within them, but we momentarily need to learn only these four groups.

CHEST & ABS
These areas of the body are the easiest to learn because society shows them to us all the time, thanks to posters of shirtless models with sculpted abdomens and voluminous chests. When you draw them, try starting with a vertical line that cuts the body in half (the same one we saw earlier when we talked about the mannequin.

OBLIQUES
Think of the obliques as columns of muscles composed of a family of six pieces. They follow the entire line of motion, then intertwine with another group of muscles in a "braid-like" fashion toward the side of the torso.

BACK
The back can be tricky to learn and understand. Let's keep it simple. As you can see in the picture on the left, the major muscle groups have been broken down and are more understandable. Remember these shapes and devote many hours of practice to trying different poses; as you get better at it, add more and more details.

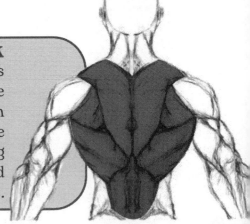

The torso is capable of any manipulation. Use a center line as a guide. Divide in the middle of the center of the chest and abdomen to have your reference point. Remember that the chest is connected to the shoulders, so when the arms go upward, they pull the chest with them. On the other hand, when the arms are toward the front, the chest is compressed into a much narrower space, but it leans forward.

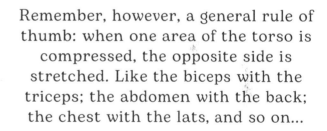

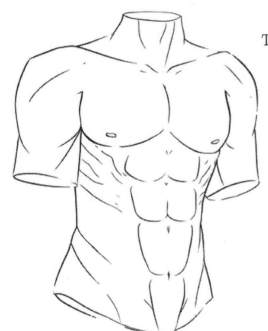

The abs and obliques have almost an accordion effect in how they push and pull against each other.

Remember, however, a general rule of thumb: when one area of the torso is compressed, the opposite side is stretched. Like the biceps with the triceps; the abdomen with the back; the chest with the lats, and so on...

When the torso is bent forward, the abdomen is compressed into a tight group; instead, the back is fully extended.

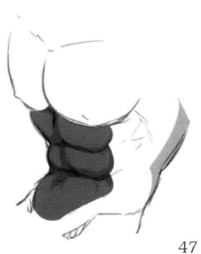

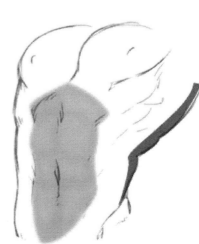

Instead, we have the opposite: the abdomen is stretched, and the back is compressed. All this occurs when the torso is bent toward the back.

47

3.3
Female Torso

I have noticed that the female torso is much more pleasant to look at but more complicated to draw. Unlike the male torso, drawing a female body requires a lighter hand and much more twisted and curved strokes, accentuating the shapes more.

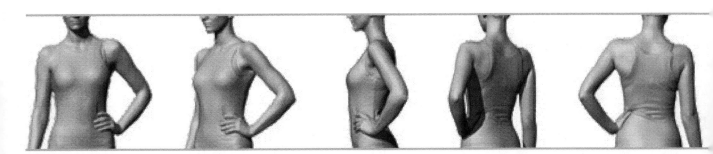

Female traits

Unlike drawing a male body sculpted like a statue of some Greek goddess, for the woman, the matter changes. Remember an easy rule when adding detail to the female body: less is more.
Too many lines, and you'll make a little maiden look like a bodybuilder.
Try to work with curvy, flowing lines and especially the important curves.

Look at the figures, and below you will find some features that will help you accentuate the feminine figure:

A slender tall neck
Visible collar bone
Simple, minimal lines to represent the abs and bottom of the Ribs
An arched back
A slighty pronunced lower belly
Wipe hips and a curvy bum

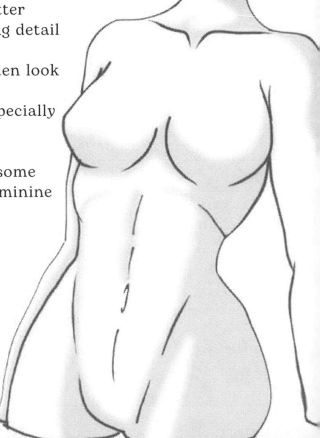

Don't be shy about drawing feminine curves; with a bit
of practice, you will notice how your female bodies will
immediately take on unique femininity.

Rule No. 1 is: draw, draw and draw.

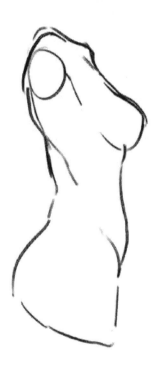
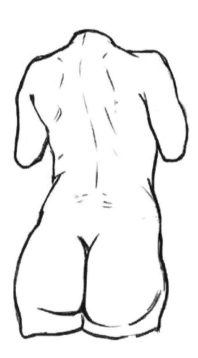

A general rule of thumb is to draw women keeping the
breasts and hips in a reasonable proportion to each other.
If the female body is unbalanced and there is no balance, you
will notice it immediately as it will look unnatural.
Of course, there are exceptions. Look around, and you will
notice women with small breasts and wide hips, or vice
versa.

3.4
Arms

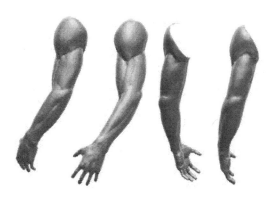

Male

Female

Shoulder
The shoulder is divided into three main muscles held together in a "love heart"-like shape. The front section is connected to the chest. The section in the middle is connected to the arm and neck, and the back section, on the other hand, is connected to the back muscles. The pass part of the deltoid is in the shape of a "v" in the middle of the triceps and biceps.

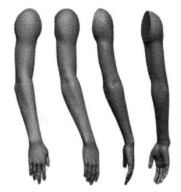

Triceps
The triceps is the opposite of the biceps in both form and function.
They are a group of two muscles combined to take the shape of an inverted U, wrapping half of the back and the other half at the biceps.

Biceps
It is our excellent performing muscle.
It starts just below the front of the shoulder and ends on the inside of the arm opposite the elbow.

Forearm
The forearm is an area of the anatomy that confuses so many people.
The forearm consists of two parts: the first is a group of two muscles that wrap over and around the upper part of the forearm; the other is thin and starts on the inside of the arm and ends toward the little finger.

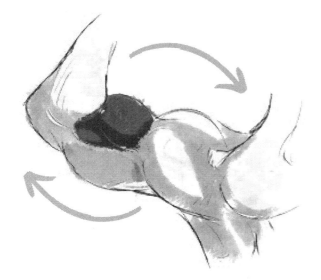

The biceps pulls at themselves; the triceps, on the other hand, pushes away.

Imagine observing a saw, you pull and push, and the opposite muscle is activated each time.
When one is compressed, the other is in extension.

The shoulder pulls on the chest and back muscles when it is compressed. The shoulder is also the most important muscle area we have to draw because it is connected to the torso, neck, back, and arms.

Remember that girls have muscles too!
Just try to draw them in a more elegant and minimalist way.
Try drawing only the silhouette of the muscles.

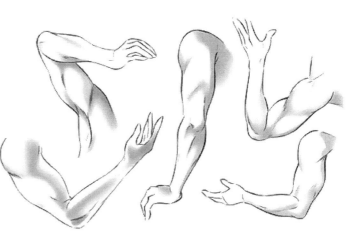

3.5
Legs

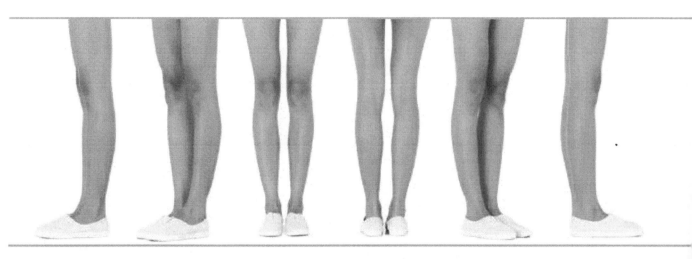

Legs contain structures that many artists initially may be unfamiliar with. This is because they tend to draw little or avoid them! Simplify them into simple geometric shapes, and you will see that they become easier to draw and much more understandable.

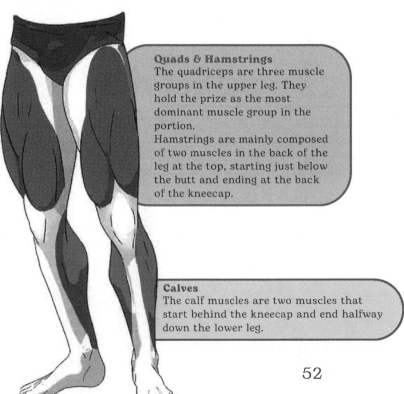

Quads & Hamstrings
The quadriceps are three muscle groups in the upper leg. They hold the prize as the most dominant muscle group in the portion.
Hamstrings are mainly composed of two muscles in the back of the leg at the top, starting just below the butt and ending at the back of the kneecap.

Gluteus
Remember that the lower part of the butt should "tuck" into the leg. A muscular butt has a bulkier appearance and is flatter on the sides.

Calves
The calf muscles are two muscles that start behind the kneecap and end halfway down the lower leg.

52

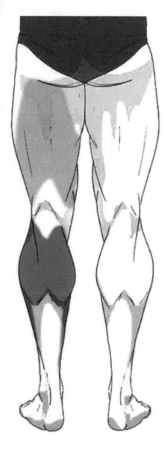

Each muscle group has a specific task:

The quadriceps are responsible for weight bearing and lowering

The calves move the foot around

The buttocks and hamstrings are responsible for pushing body weight upward.

Beautiful slender female legs are vital to a female figure, even if we intend to depict a sexy woman in an illustration. Like any other muscle group, don't overstress the lines, and always keep them as light as possible.

Remember this advice:
Try to keep the female legs gradually narrower by going down to the leg part.

53

3.6
Hands

In realistic drawing, drawing human hands turns out to be very difficult; for anime it is not so complicated compared to realistic drawing. The reason is because in anime characters we remove a lot of detail and try to stylize it into our own style (or that of a particular anime we are fond of). When you watch your anime on TV or while reading Manga you will hardly see hands, even to a lesser extent feet (usually covered by shoes).

Remember that female hands are thinner and more delicate than sturdy male hands.

In male hands you will be able to add more details such as, for example, veins.

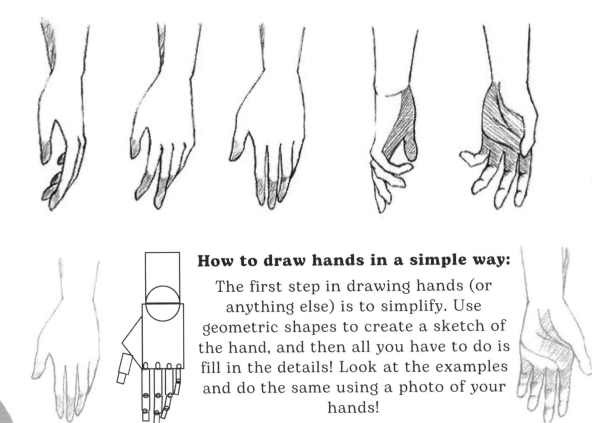

How to draw hands in a simple way:

The first step in drawing hands (or anything else) is to simplify. Use geometric shapes to create a sketch of the hand, and then all you have to do is fill in the details! Look at the examples and do the same using a photo of your hands!

Use a square or rectangle to sketch the palm and back of the hand; thinner, longer rectangles to sketch the fingers; circles to sketch the wrist and finger joints; ovals to sketch the position of the knuckles; a triangle to sketch the beginning of the thumb; and so on.

55

To make the concept expressed above more understandable, we will use the "simplification" technique on real hands:

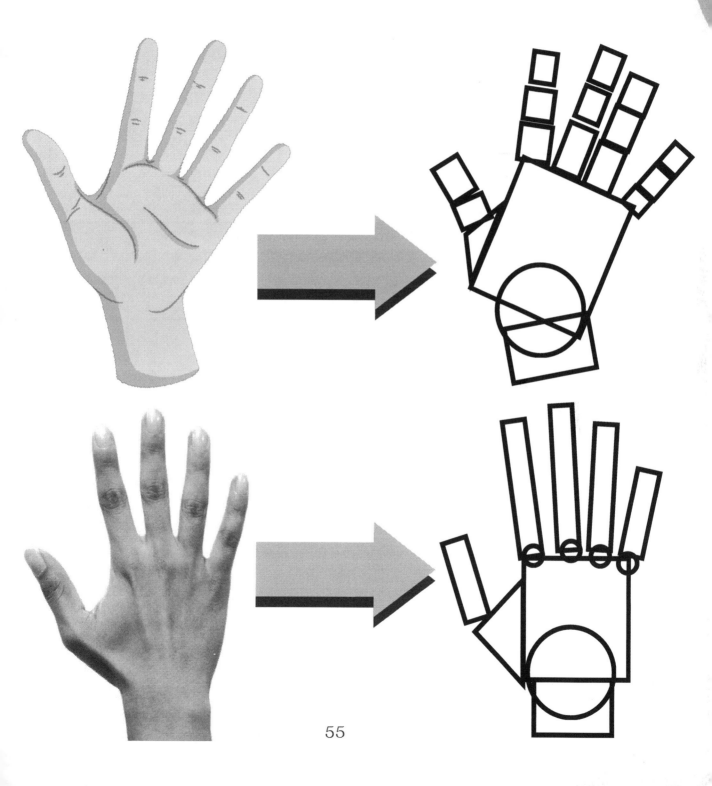

55

TRY IT YOURSELF!

3.7
Feets

The feet of anime characters are probably the last thing you need to worry about. Since you will rarely see feet in manga or anime, this is because usually feet are covered by shoes.

Sometimes, especially in some scenes, some artists need to draw them. Luckily for you, there are only a few things to remember when you need to draw feet (one among them is the "simplification" technique). The first feature you will need to remember is that women's feet are always smaller than men's feet, both in length and width. The second thing you will have to pay attention to is that women's feet are generally closer together; while men's feet are further apart. The third is that the female ankle is drawn curved inward; while in men it is drawn curved downward. Fourth and last thing: simplify by using geometric shapes.

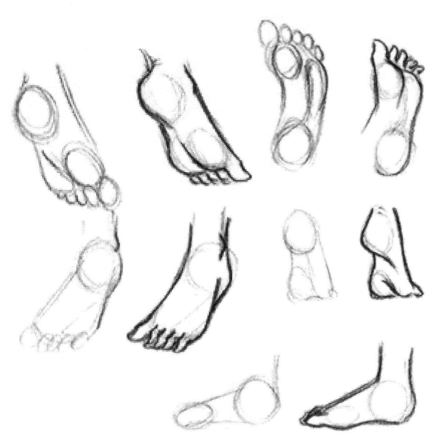

How to draw feets in a simple way:

The process for drawing feet is almost identical to that of illustrating hands. All we will need to do is to use geometric shapes to sketch our drawing of the feet. We will use ovals to sketch the heel and the front of the foot, and next we will go to join these two ovals, remembering that the bottom of the foot is slightly curved inward.

TRY IT YOURSELF!

3.8
Drawing the body

The total length of a manga character's body is different and each one is on its own. In the first part of this book we talked about the proportions of the body , but not how it should be drawn. Keep in mind what was said in the first lesson regarding anatomy and let's continue with the technique of "simplification" using geometric shapes, as we did previously with hands and feet. I recommend that you use many pictures as references so that you can study the correct shapes and proportions.

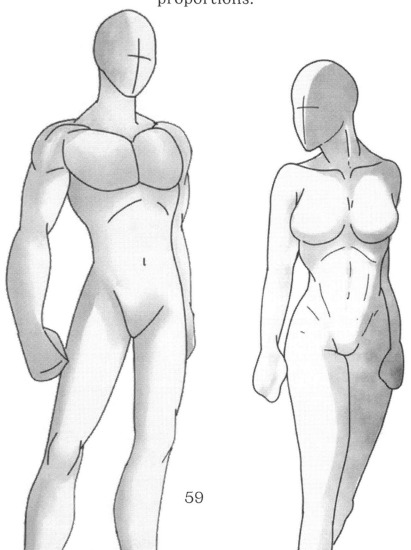

STEP 1: SIMPLIFY

Take an image as a reference, you can use an image of a celebrity you like, or a particular pose of a favorite character of yours, it doesn't matter.

Once you have a pose you like for creating your character, start simplifying it by using squares, circles, triangles and/or simple lines. There is nothing complicated about this, plus it will make your job so much easier.

Use the squares for the hands, the oval for the head, the circles for the joints (shoulders, hips, knees, ankles, elbows, wrists), the lines use them for the arms and legs, but also for the torso. At the end of the work you should end up with a kind of mannequin like the one on the right here.

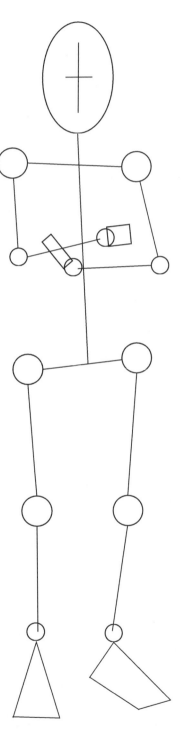

60

STEP 2: ADD VOLUME

Turn the lines into triangles to add muscles. You can illustrate the torso momentarily with sturdy rectangle and the pubic area with a triangle. Practice creating drawing dummies to give that extra touch to your characters.

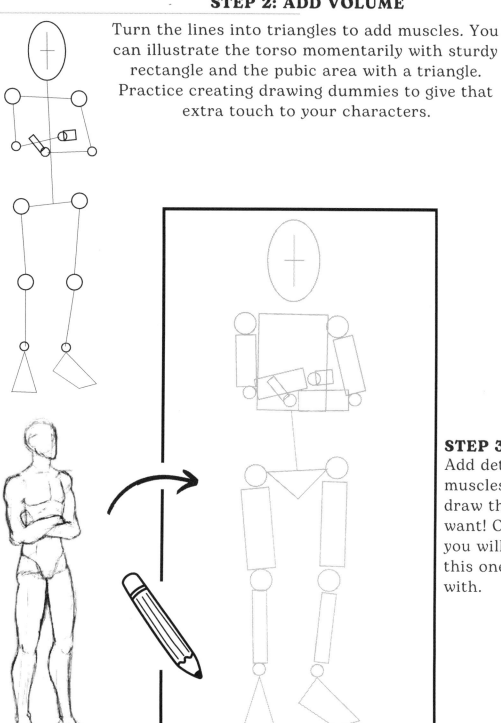

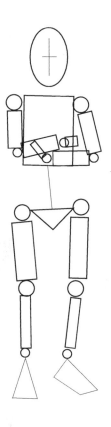

STEP 3: DRAW!

Add details such as muscles and face and draw the character you want! On the next page you will find more like this one to practice with.

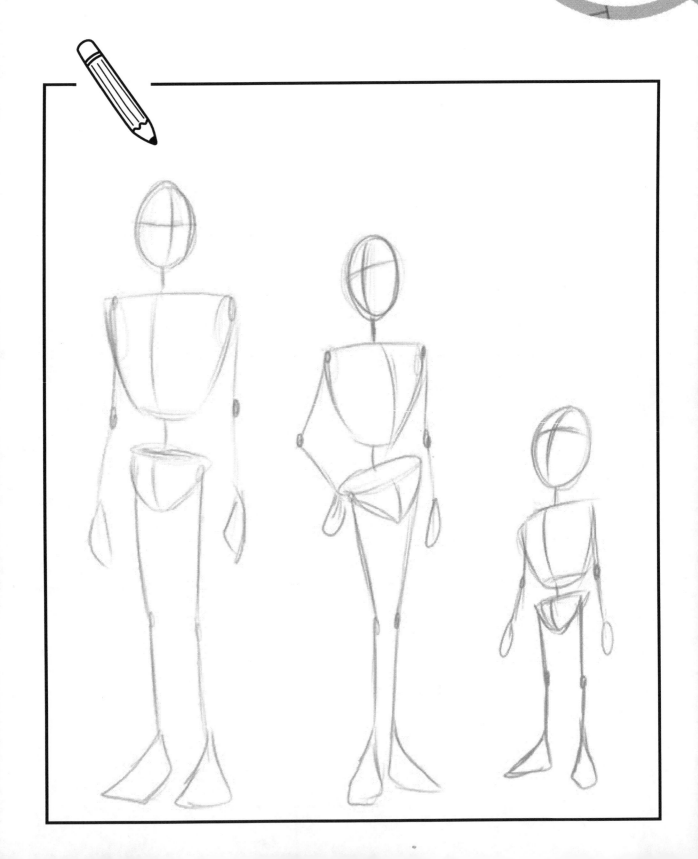

TIPS & TRICKS

When creating the mannequin remember that in the male torso you will need to keep the top much wider than the bottom to give your character more masculinity.

Unlike men, women turn out to be wider in the pelvic area and have their shoulders closer together. Try to highlight this feature to give more femininity to your female character.

Lesson 4
Clothes

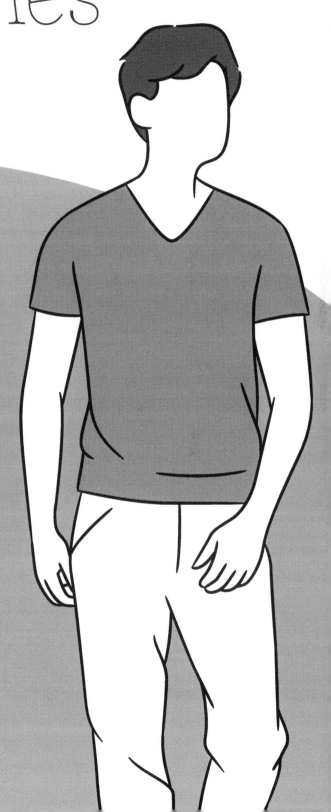

3.1
Folds

Folds are caused by the presence of gravity pushing clothes downward. Different materials will have many more creases than others, but the process is still the same. Usually, thin materials create many more folds; for example, a women's dress is made of light fabric. Usually, every crease has its shadow, so there will be a shadow where there is a crease. The shadow follows the direction of the fold.

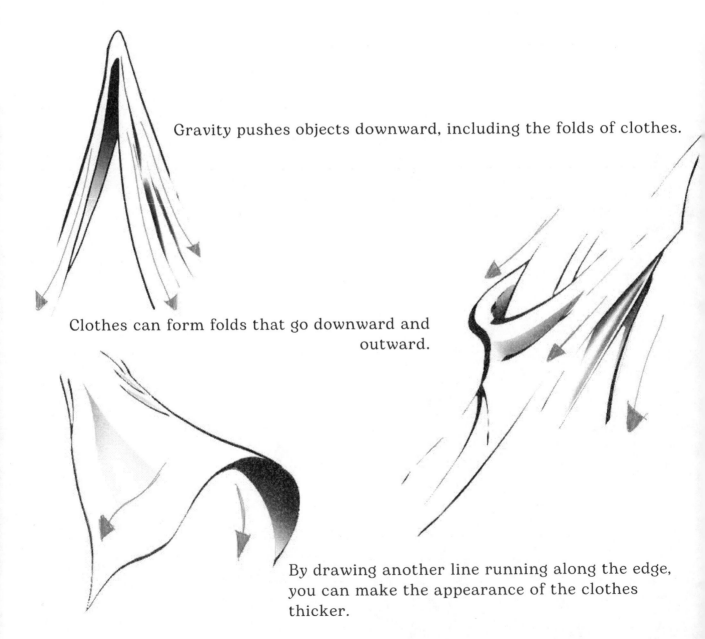

Gravity pushes objects downward, including the folds of clothes.

Clothes can form folds that go downward and outward.

By drawing another line running along the edge, you can make the appearance of the clothes thicker.

The folds of the clothes that form on the arms should go downward and outward. It would help if you always remembered to keep it as simple as possible at first. The folds take time to understand, and also, a lot of mangakas tend to draw them incorrectly.

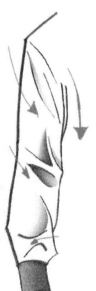

With the arm at rest, folds tend to form in three different areas: the shoulders, inner elbow and above the wrists.

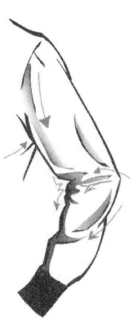

If we bend the elbow outward, we will immediately notice that the shoulder line will change and more folds will form under the armpits, but especially in the inner area of the elbow that so many small folds will form and everything will tend to resemble a rotated "Y."

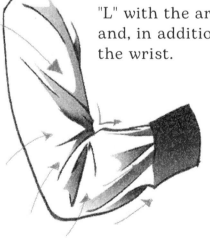

If we bend the elbow completely, forming a kind of "L" with the arm, the inner elbow folds will be many and, in addition, will tend to go in the direction of the wrist.

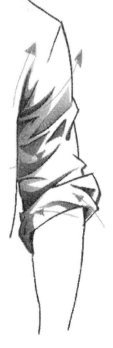

If we roll the long-sleeved shirt into half-sleeves, we will immediately notice that extra creases will form in the inner elbow and armpit area.

3.2
Male Clothes

The easiest way to draw clothes for a male character is to draw him in a T-shirt and a pair of jeans. What matters is not how he is dressed but the theory behind the folds of the clothes.

Shirt creases in a male character tend to form more in the shoulder area and the area near the chest.

Trouser folds, on the other hand, form below the waistband and the zipper.

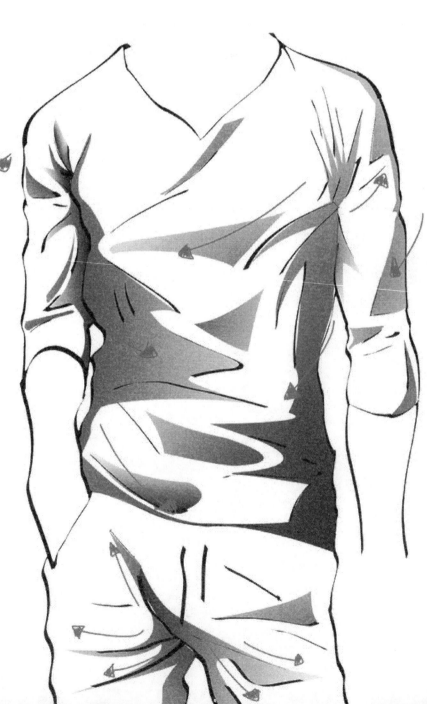

Clothing folds can become even more complicated than expected when we draw a character that moves, for example, with arms or legs raised. Remember, however, that tension points (such as elbows or bent knees) do not create folds.
Study the examples below.

Observe the drawing here on the left. You will notice right away that there are points of tension where there are no folds (the knee up and the buttocks), and then immediately look to see the areas where there is less tension and where there are more folds (below the waistband and near the ankles).

A well-ironed jacket will tend to produce far fewer creases because it is made from thick materials and is almost always tailored. However, when drawing clothes to a back character, remember that creases will form in a "V" shape, as in the case of the drawing to the right here, or a "U" shape, depending on the material and size.

Remember that the folds follow the body's movements, and as you can see from the drawing on the left, raising an arm changes the direction either in the same or the opposite direction.

3.3
Female Clothes

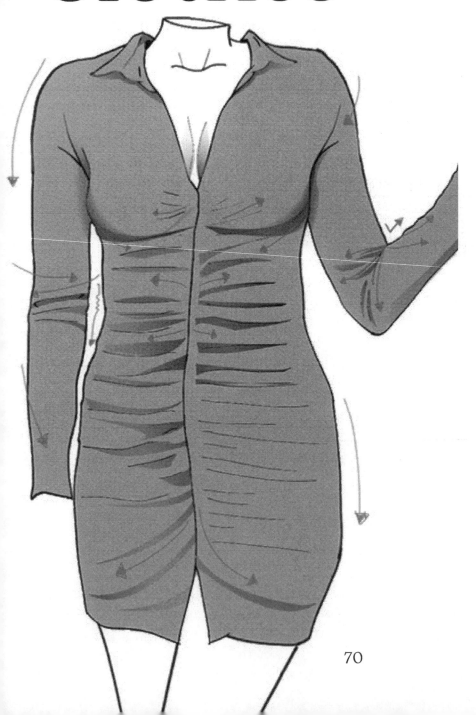

Drawing the folds of female characters is slightly more complex than drawing those of a male character since you will have to worry more about extra folds in the breast area. As I remember throughout the book, you should always start with simple lines and from drawing only essential folds and gradually, as you get better at it, insert more and more details.

In the drawing on the left, I have chosen to illustrate a fitted dress split in half, like a shirt. Immediately you can see that a tightly worn face will produce lots of folds concentrated in small areas, but few concentrate on the overall dress. Usually, tight-fitting dresses can be complicated for beginners to draw. The breast area, in this case, will produce very few folds compared to the examples on the next page.

70

When we design a feminine skirt that is not too tight, we can divide it into sections, thus giving it a more three-dimensional shape.

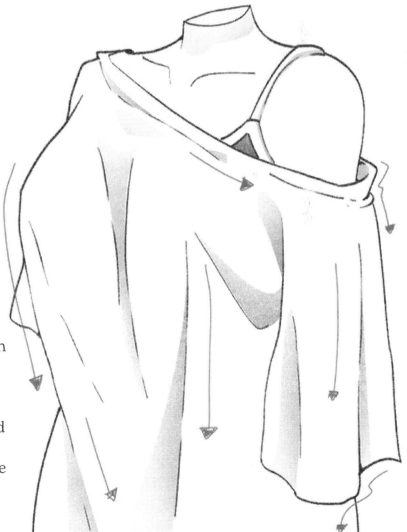

When clothes are loose, it is preferable not to draw too much breast detail as it distorts the design. In many anime, it is common to draw voluminous breasts and to make them stand out, and you end up forgetting to properly draw the folds of the clothes in that area.

3.4 How To Draw Clothes

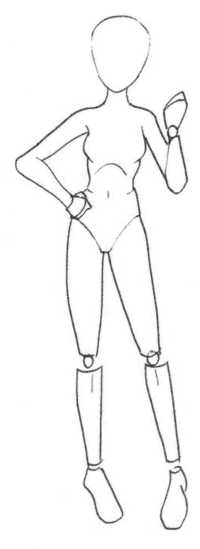

STEP 1

To at least realistically draw the folds of the clothes and the clothes themselves, you need to sketch the physicality of your character and create the dummy in a way that allows you to have a clearer idea of where to place the folds.

In the figure on the left, I have chosen to draw a female character, but the process is the same for every type and gender of the character.

STEP 2

Once you have created your dummy, look at pictures of clothes that you will use as a reference to figure out how the pleats are created, and then, with a colored pencil, use triangles, arrows, and curves to sketch the areas where there will be wrinkles and in what direction they will go and also use geometric shapes to get an idea of the volume of the clothes.

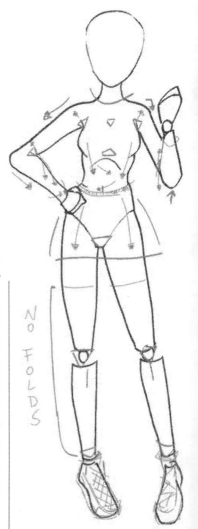

NO FOLDS

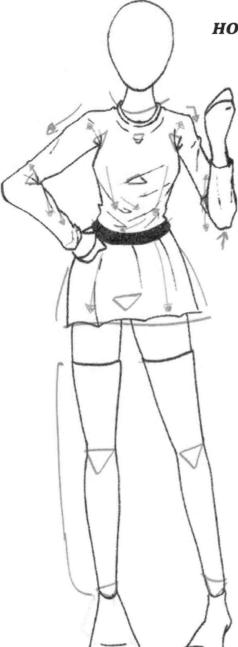

STEP 3

Draw your clothes, keeping in mind the sketches you made previously, and proceed to adjust any details on your mannequin.

STEP 3

Erase the sketched lines of the wrinkles, and then you will be left with only the line art of your dress, complete with folds.

At this point, the result has already been completed, and you will have your clothes with the attached pleats, all by simply simplifying the various lines of the wrinkles, as you were able to observe in *STEP 2*, but let's move on to the coloring.

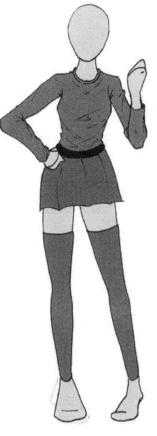

STEP 4
Start by coloring with flat colors that are neither too dark nor too saturated, as we will later go on to darken and lighten them.

STEP 5
Add shadows. Drawing shadows is not that complex but still requires some practice. I recommend looking at the fold line and creating triangular shapes to create shadows opposite the direction in which we draw the lights.

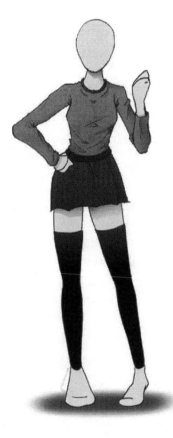

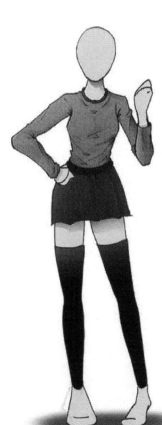

STEP 6
Add lights.
Try to light the areas opposite the shadows in a way that gives a more three-dimensional effect to your design.

Conclusions

Drawing anime, as well as drawing in general (from cartoons to more realistic and complex drawings), requires a tremendous amount of effort and just reading a book is not enough to make you a professional mangaka; however, you can use this book as a powerful tool in which to brush up on the basics and always using real models for your drawings so that you can accurately study anatomy.

The art of drawing is a powerful tool that allows us to make real, illustrate, and shape our imagination. Drawing is a most powerful tool in this respect.

Keep studying and devote hours and hours of practice to become a great illustrator, and the next world-famous anime can be yours.

Made in the USA
Columbia, SC
08 December 2024

48703377R00043